Paper Sky

Also by Kathleen McGookey

Whatever Shines

We'll See
(translations of Georges Godeau's prose poems)

October Again (chapbook)

Mended (chapbook)

Stay

Heart in a Jar

Nineteen Letters (chapbook)

Instructions for My Imposter

Cloud Reports (chapbook)

Paper Sky

PROSE POEMS

Kathleen McGookey

Press 53
Winston-Salem

Press 53, LLC
PO Box 30314
Winston-Salem, NC 27130

First Edition

A Tom Lombardo Poetry Selection

Cover image by Mariano Avagnina,
acquired through Pexels

Library of Congress Control Number
2024941934

ISBN 978-1-950413-86-7

For Jack Driscoll

The author wishes to gratefully acknowledge the editors and staff of the periodicals where the following poems originally appeared, sometimes in slightly different versions.

Copper Nickel, "Box," "On I-96"

DMQ, "Cloud Report, 10/20/22," "During the Pandemic," "I Didn't Want to Love the Dog"

Dunes Review, "Early Valentine," "How to Comfort a Lost Star," "My Mother Makes a Lemon Cake"

ELJ, "Long Walk in the Dark, August"

Epoch, "Constellations"

-ette review, "At the Far Edge"

Faultline, "Grief Is a Parking Lot," "Sleep Study"

Glassworks, "Small Words"

Hotel Amerika, "Elegy for My Loneliness"

The Journal of Compressed Creative Arts, "AP English Assignment," "Exam"

KYSO Flash, "Circus Love Story," "Like Startled Sparrows"

MacQueen's Quinterly, "581 Prestwick," "A Month Before They Died," "Cloud Report, 5/24/22," "Inside Out," "Little Gold Door," "Magnificent Error," "The Sleep Thief," "Without You"

Mom Egg Review, "A Rough Translation of Motherhood"

MSU Libraries Short Edition, "The Color of George's Fur"

On the Seawall, "Nightly," "Poem Obscured by Sleep and Fog," "Under a Cloudless Sky"

One, "Cloud Report, 5/28/23"

New Flash Fiction Review, "Junior Year Abroad," "Santorini, Remember?"

New World Writing Quarterly, "In My Hometown Library," "Workshop"

North American Review, "Bearing It"

Poetry East, "Redux"

Prairie Schooner, "Pandemic Ode"

Punctuate, "Picture of a Young Elk" "We Had Our Share of Beautiful Days"

The Southern Review, "After Sliced Bananas, After Bath Time"

Sugar House Review, "Asking and Asking," "At Miner Lake, Again," "Temporary Charm"

Sweet, "Cloud Report, 11/8/22" (as "Dear Rebecca"), "Loons at Dawn, Gun Lake"

SWWIM Every Day, "While You Were Gone"

32 Poems, "Night Sky with Calculus Worksheet"

Waterwheel Review, "Beginning with a Line from Roethke"

Willow Springs, "Cloud Report, 2/9/23," "Cloud Report 3/13/23"

"Box" appeared in *American Life in Poetry*.

"Workshop" was reprinted in *Best Microfiction 2023*.

"Broken Down Ode" and "Still" appeared in *Dreaming Awake: New Contemporary Prose Poetry from the United States, Australia, and the United Kingdom*.

"Night Sky with Calculus Worksheet" was reprinted in *Fantastic Imaginary Creatures*.

"Cloud Report, 5/24/22," "Cloud Report, 10/20/22," "Cloud Report, 2/9/23," "Cloud Report, 11/8/22," "Cloud Report 5/28/23," "Cloud Report 3/13/23," and "Cloud Report, 1/18/23" appeared in my chapbook *Cloud Reports*, published by Celery City Chapbooks.

"Sky Spirit" was inspired by Maryellen Hains' artwork of the same name and appeared at the Equinox Exhibit, Ninth Wave Studio, Kalamazoo, from 9/8/20 – 10/23/20.

"Circus Love Story" was inspired by Michael Dunn's artwork and appeared in the 2017 show "Drawing on Words" at the Kalamazoo Book Arts Center.

Contents

Early Valentine

Snow swirls past my window and settles in drifts that cradle the roof, until only a few black shingles peek through. It muffles the phone, the blood test, the dishwasher's carcass, dripping. A cardinal lands near the feeder, stark as a heart. A gray squirrel nibbles a slice of red apple it holds in its paws, tail curled like a question mark. Let the snow's hush fill us like the breathing of an old dog, asleep by the fire. All day snow falls against the backdrop of more snow.

Cloud Report, 5/24/22

This morning my mirror reflects a fallow field, lush and overgrown, with three fawns stepping through it. A red-winged blackbird lands in the autumn olive, whose pale creamy buds are ready to burst. What a relief not to see my face aging in front of me. Instead, my mirror shows pearly sky heavy with clouds but lifting at the horizon. While I watch, the darkest clouds drift up and out of the frame, and then rain falls so thickly I can barely see the field. After it stops, a wren begins the day's work, calling *teakettle, teakettle, teakettle* and searching for any hollow object to fill with its nest.

Small Words

On Cherry Valley Road, look for the catalpa with a hole in its side, where the trunk branched and half tore away in the storm. You could stand on tiptoe and hide a measuring cup and a spinning wheel in there. I pass it twice a day, taking my kids to school, but today, I can't stop and guess a hundred names for love. Not even one. A mass of white petals litters the ground. Some days I glance at the jagged hole and wonder if it's growing teeth. Some days, while the kids argue, I think about dinner. About the bats living in the eave and the ladder. The lost language-arts book, surely damaged in the storm. My daughter's teacher wants her students to stop using small words like *little* and *pretty*, in favor of more complicated ones. She's made the classroom bulletin board into a graveyard, miniature headstones marking each discarded word. I see her point and disagree. After dinner, the dog and I walk in the dark while the wind shakes a little more rain from the trees.

Asking and Asking

If you squint, if you follow the path of the sparrow that lands on the spiky weeds in the field, you might find me, under the same paper sky. The oaks have just started to turn. In their canopy, they hold the call of an owl, which sounds like my child, asking and asking. I take a breath and try to rest. The sky is white as sleep and just as vast. Here I am, reaching out a hand—

Poem Obscured by Sleep and Fog

The morning stutters a little when my daughter oversleeps.
But her socks are clean and she washed her hair last night.
Her brother says, *Wear the black windbreaker. It looks nice.*
I slice a pear, wishing for minutes to pass like yellow leaves
drifting to the ground. Her biology homework is done,
diagrams of cell walls drawn in purple ink. Soon enough,
she carries her backpack into the darkness, into the fog, past
the field which wants nothing, not even sun on its lovely slim
grasses, or wind, or snow. My heart settles down like a cat
curled by the doorstep, who, having survived the wet and
starless dark, now waits to be found.

Rescue Dog

When the golden rescue dog and I are alone in the house, mornings, evenings, or afternoons, and I'm upstairs, invisible, and he is struck by loneliness, instead of climbing the stairs to find me, he stays curled on the down comforter, sun slanting around him, or pressed against the back of the couch, or—especially—sprawled near the warmth of the fire; he stays put and howls as if he were trying to call his heart back to his body. It used to make me laugh. But, Reader, isn't that what I'm doing here with you?

AP English Assignment

It's totally effort-based, my son says. *To get an A, all we have to do is write two pages on true wisdom and happiness.* But the students must have to do more than write a description of a night like the August night years ago, at Gun Lake, when the wind slowly blew the clouds away from the moon and the boy I was beginning to love and I saw the water come alive with the golden bodies of hundreds of minnows flashing through the shallows. And though the humid air was filled with mosquitoes, not fireflies, and though the boy laid his palm on my stomach and I can't remember what he whispered, except that it made me laugh, nothing was decided and yet everything was, our future a box wrapped in moonlight, my parents still alive and watching television in the cottage behind us, blue light flickering at the edge of our vision. Dying was for other people, nothing to spend even a minute on then, under that moon, watching those minnows, the lake like another presence breathing with us in the dark.

Broken Down Ode

To my feet, with their bunions and dry cracked heels, which carry me through my days, and once carried me, carrying you. To the chipped kitchen sink, where you used to fit perfectly for a bath, and to the water that made you laugh, slick as a shining fish. To the neighborhood rooster that crowed through our nights and days and nights, as they bled into each other. To the deer that nibbled our hostas to the ground and left their heart-shaped tracks among them. To your surgeon, your surgeon, and again to your surgeon, human in his blue scrubs. Oh Beauty, oh Truth, what do you have to say for yourselves? We are suffering in so many ways now, even at sunrise, even as the white-throated sparrow fills the air with song.

A Poem Is a Little Church, Remember?

Where peach trees flourish year-round, heavy with fruit. Where bluebirds perch in the branches, then swoop down to eat from our hands. Where the barn owl's eyes are yellow as flame and do not flicker, but the river flickers alive because we've put peaches, those tender jewels, inside it, and the current carries them away. We don't name the river, whose banks glisten with dragonflies that emerge from the water, then practice opening and closing their glassy wings. In the little church, a door opens. The door is red, the door is wood, the door is wrought iron and we have the skeleton key. It opens onto a courtyard with a fountain that sounds like the river, tamed, whose only business is wishes. What's better than a held breath, a tossed coin? A pocket, freshly mended, or a crop of lost pennies scattered on the path, their coppery, ridged faces reflecting the sun.

Cloud Report, 10/20/22

When you begin a poem *In Paris*, that phrase carries the weight of centuries, of cathedrals, of silk scarves trailing perfume as you chase a taxi through the dark, in the rain, laughing. But Paris is over there, unaware of its cachet. And I'm here, looking out the window, and already I feel everything must be better in Paris, the windowpane being French, the view of a quiet street lined with cars, so French and thus extraordinary. Okay. Back then my feet weren't cold and my wrist didn't ache. I wore my passport under my shirt, in a little cloth pouch my mother made. It was hidden and therefore ideal. And my dreams? Not of looking at clouds, familiar and strange, silvery mounds lined with shadow, a whole sky full, so low and heavy they'd crush the trees and the field and my pale house here at the edge, here where I ended up, if the sky would ever let them go.

At Miner Lake, Again

Someone plowed under the tangle of raspberry vines where you knelt and offered me a diamond ring. Someone painted the emerald house beige and added a proper fence. I'd restore our little garden—zucchinis and cukes, marigolds and daisies—shaded by the garage. And the rope hammock, languid between the oaks by the lake. But the cottonwoods and maples, though taller, still sway in this late September breeze, which is still a little warm and smells of peaches, while the clouds tumble quickly toward dusk.

.

Still

Two layers of clouds sheer as bridal veils glide fast in opposite directions, edges blurred, swirling me in white and blue, even though I'm below all that motion, sitting still. Remind me, was there still snow on the ground when the world stopped, churches and bars and schools closed, everything canceled? Was there wind? Each day stretched three times its usual size. In our house, no one sang, though many nights we played euchre at the kitchen table. Once, the lights flickered out. The next morning, the well pump quit. Our house became an island, shuttered tight against the news. But it still leaked in. Night and day behaved themselves, at least, and lined up to walk on sock feet down the hall. From time to time I sat in the attic, wrapped in blankets, and watched the aspen's branches scrape the gray horizon. We fed our worry to the bluebirds which nested just inside our yard. Our supply was abundant. The young birds grew strong and practiced flying among the branches, then perched next to each other, briefly, three on one branch, two on another, like bright scraps of sky.

The Color of George's Fur

It's not the color of the center of the flame. Or the tip, as it flickers and then dissolves. A candle's flame, not a roaring bonfire. Almost like the sheen of brass. Close, but not quite. Warmer. Not that nearly artificial hue the trees blaze, briefly, in October. More like bronze fabric, with a little shimmer woven through. To throw off some light. (If he naps in the sun, imagine all this several shades warmer.) Not a color you can bring home in a box. Why bother getting it right? He's darker than our first beloved golden. And younger, of course. And competing with our best memories: sprinting like a young deer after the herd; napping, chin in bowl, waiting for dinner; leaping out of the rowboat to join the swimmers; zooming in figure eights in the yard, delighted to see us. Like a young fox, this new dog's as burnished as Buddha's belly. Right now, he curls on his bed in a tight ball, nose to tail, eyes shut. Resting up to break my heart.

Like Startled Sparrows

The clocks fly past the tablecloth sticky with syrup, past the beds rumpled as daisies, past the mason jars filled with pearls and rice, to perch at the windowsills. You can hold your breath but it's already too late—the daffodils by the foundation have laid down their filmy trumpets while dandelions overtook the field. Grandfather and grandmother have stepped back into their portraits—one stands in the center of the team, holding the championship basketball, the other sits at a little wooden desk, smiling and gripping her pencil.

Beginning with a Line from Roethke

I, too, have known the inexorable sadness of pencils, the Dixon number 2s my sister-in-law mailed after Van died, twelve boxes, so old their erasers left fleshy smears instead of rubbing out my mistakes. What happened to his greenhouse, bought in Denmark? To his hoses and ropes and terra cotta pots stained white with minerals? His tulip bulbs, seed catalogs, broken Underwood typewriter? He had been dying so slowly it seemed just like living. This was after the virus but before the vaccine. Should we have driven through the night, slept in the van, waved at his picture window? We didn't know. We didn't know that afternoon at the lake, five years ago, would be the last. What happened to his cookbooks, bundt pan, whistling teakettle? The child-sized red wooden shoes from Holland? His ancient reel-to-reel tape recorder, displayed for decades on the bookshelf behind glass doors, and leaning beside it, the sloppy stack of reels, safeguarding his children's voices?

Grief Is a Parking Lot

Is the darkness already inside me when the vet calls, when my son calls, when my kitchen window delivers delicate yellow shoots of daffodils emerging through snow? The person I most want to tell has been dead almost a year, though just this week he showed up in my dreams, complaining about the price of bagels. Anyone who says we have enough time is lying. Even on our visit to a fancy private college, our parking spot at admissions labeled with my daughter's name, the high-priced minutes ran out. We'd felt golden to have a place reserved just for her. After we shut the car doors, a flock of glossy swallows charmed us, swooping from tree to tree, then loop-de-looped through the picture-perfect sky, which had to bear all this—and all to come—with stoic, detached grace.

After Sliced Bananas, After Bath Time

I'd lie on the carpet and nestle you on my chest. One sweet part of a long, long day. You had just learned to crawl. I was greedy for ten minutes alone. It's possible I am not remembering this correctly. The carpet was ripped and stained. Or the carpet was newly installed, just after we painted clouds on the light blue ceiling. Every night I stumbled into an unused room at the top of the staircase where you slept, enchanted, in the leaf of a water lily. You woke when I gathered you up, and told me everything then, while I held you at the window and translated the dark trees, the stars, the unraveling wind—

Junior Year Abroad

I intended to live one significant moment after another, beginning with that tiny bottle of Dior cologne in the cramped bathroom of my Air France flight. This was the *before*. Before the man next to me sighed and scribbled apologies to his beloved all night long. Before I rode the train carrying a bouquet of violets. Before I sat in cemeteries at noon, chewing my baguette. Before the lost passport, the bad haircut, the tripped fuse that knocked out power to a whole apartment building. Before my teacher burst into our classroom, clutching the novel she assigned, and pointed at me. Of course I confused key points: Did the piano really mix cocktails each time it was played? Did the young woman grow a water lily in her lung? Yes, she was tragically beautiful, red-haired and pale. Yes, the owner of that wondrous piano briefly married her. But understanding the book was like trying to touch a whitecap on an ocean wave as it washed back out to sea. Even now, I still hope to stumble across the definitive English translation.

Santorini, Remember?

I fell in love with your blue, stretching for miles to the horizon, all that undulating, shivering blue. I fell in love with your whitewashed houses silhouetted against it. Back then, the book in my backpack told me where to catch the train or the bus or the boat. We rode the ferry from the mainland to save the cost of a room. Donkeys hitched to wooden carts pulled us up to the dusty town square filled with strays and a dusty bus, which took us past olive groves to ruins in a field, gray pillars and statues with no faces or arms. Back then I thought time was your ocean, endlessly shimmering. Now I know time is a rope with a noose. It was Easter, though we had forgotten and asked a girl in her yard why every bell on the island was ringing. She mimed a scarecrow—arms out, head lolling, dark hair cascading down. It was years before I understood. I bought a string of black beads etched with gold. I bought leather sandals that laced up my calves, and then we ate calamari in spicy red sauce straight out of the can. For dessert, we ate thick yogurt with honey, then held the honey jar in front of the sun.

In My Hometown Library

I sat with a poet I loved like a father, reading poems. They were my poems, and I wanted to know what to do. Let me say this kind of dream has never come to me before. I passed manuscript pages to the poet I loved like a father, and he passed them back to me. Mostly, he said *yes*. The rest of the dream was the motion of deer crossing a dirt road at twilight, clouds rushing ahead of a storm. We sat in cushy armchairs by a gas fireplace, and golden light flickered across his glasses. The librarian with red hair came by and asked us to join the famous poet whose reading was just now starting. *Why not?* my friend said, and held out his hand to help me onto the stage.

Without You

After your wife dies, you write that you're moving back East, so I drive three hours to see you. You're dragging a hose across your yard, bandanna around your head, not expecting me. *Let's sit by the river,* you say, and I ask, *Would you mind if I get my dog from the car?* Your hips give you some trouble with the stairs to the small wooden deck. We're talking about packing, selling the rare books, sedating your cat, when two chickadees land in the branches above your shoulder. They're waiting to eat from your hand. What will they do this winter without you? The sun warms our faces. While light sparkles on ripples the wind makes, you tell a story I've never heard: fifty-five years ago, you gave up a daughter, and now she has found you. You'd searched for her for years. I had no idea. *It's saved my life,* you say. At the edge of my vision, I'm aware yellow leaves are drifting to the water, I'm aware the river is carrying them away. My watch has slipped to the inside of my wrist; how long can I stay? My dog, who has slept between us all afternoon, sits up and yawns, and offers you his paw.

Workshop

Once I offered a poem that contained the phrase "mist shimmers" to a table full of people. One man said, *Mist can't shimmer. Fog shimmers. Mist drifts.* His name was Paul. I said nothing but, oh, I thought many things. Paul had dark bangs cut straight across his forehead, clean fingernails, and a cardigan that smelled like charcoal briquets. He sliced an apple right on top of the growing sheaf of poems, and he didn't share. He counted the rings of the apple's life. Paul said crows didn't live in Antarctica, because they couldn't cross the ocean. He seemed to know a lot about weather and birds, but little about wishbones and the kind of moss that sprouts tendrils wearing tiny triangular hats. The ringing in my ears shifted from side to side, then grew louder and faded, like some kid was playing with the controls offstage. I don't remember what Paul's poem was about.

Cloud Report, 2/9/23

Rain drips from the eave and clings to my window, smearing the horizon. The white dome of the water tower rises against it, a small bright moon. I had forgotten it all winter. What else have I missed? My clothes dryer exhales bleach-scented fog that fades quicker than breath. Now the horizon has lightened and absorbed that false moon, leaving only the sky's weight and oaks holding flocks of grackles in their wet black hearts.

581 Prestwick

The grandfather clock's musical chimes unsettle the night, marking all that time vanishing from the little Cape Cod on its neat square of lawn, shining under the streetlight. A new girl grows up in my old room off the attic; a different mother plants more white peonies in the lush flower beds. The staircase railing detaches from the wall and everything— china cabinet, baby grand piano, brass cupola—shrinks, except the maple and sycamore, which now suddenly tower over the house, cradling my childhood in their green arms.

A Month Before They Died

I took a picture of my parents holding hands. Close up, their hands filled the frame. Mine are starting to look like my mother's: wrinkled knuckles, blue veins, light liver spots near the base of my right thumb. It's not so bad. I put one over the other and she's here, holding my hand.

Box

My parents' ashes are still in a cardboard box on the metal shelves in my basement. It's not all their ashes, just my share. They left instructions, but no deadline: when the dogwood blooms, on that trail near the pines. Sometimes I feel a slight pang—is keeping them like this undignified? Disrespectful? But then I forget them until I need the crockpot, and there it is, the little box, heavy for its size, labeled in my writing, next to my daughter's baby clothes. I haven't held it since we moved ten years ago. But I might. I could.

While You Were Gone

After hours of rain, a wasp fell out of the bathroom light
and teetered on the edge of the sink. My teeth hurt. My eyes
hurt. My hair felt like the brown fern beside the front door.
Yesterday, the freezer died, the vacuum died, our second-
oldest car rolled into Speedway and wouldn't budge another
inch. Today I haven't thrown a single thing away. I made a
call, lifted the dented hood, and jiggled wires until headlights
flooded the parking lot. I can't lie: I don't want to outlive
you, sailing our resuscitated car through the abundant dark.

Eight to Ten Inches by Nightfall

My daughter built a woman from snow on our front step, then added a red apron and a witch's stringy wig. It is anatomically correct. Now I am surprised by unexpected company when I glimpse it, chalky and gleaming, through the window. But no one's really there. No one's coming, either, though we've shoveled a path to the garage. We've sent our little griefs to sleep under the maple, and a gust has erased their tracks. Near the feeder, a wild turkey flaps to clear the drift that has built itself, hour by hour, tall as a girl. The field and sky are white mirrors that make us dizzy, twins who aren't at all lonely for the touch of a hand or wing.

Redux

I hardly remember the tiny person who harnessed a hummingbird to carry her, on demand, like a horse. But the bird, glistening and wild, needed convincing. Was that the story? We used to read at bedtime, leaning against each other, inside a circle of light. Now we study star moss and mitosis. We fold laundry and search for equations written on a creased and folded paper. And if the clouds glow pink and gold, straight off the cover of a funeral program, we might stop vacuuming up dead ladybugs to notice. Last night, when we drove toward home, the moon hung so swollen, so low and red, we turned back because we had to see it again.

We Had Our Share of Beautiful Days

It was only a squirrel that dashed in front of our car, it made only the smallest thump. My faith in uncertainty never wavers. Last night, as I watered the roses at dusk, a hummingbird hovered near the spray, waiting to enter the shower of drops.

My Mother Makes a Lemon Cake

I want to sit with my mother, back in our little white Cape Cod where the family room overlooked the small backyard, shaded by sycamore and crab apple trees, rose bushes already pulled out. But I'm twelve and reading a book. My mother empties a lemon cake mix from a box, adds eggs, oil and water, and stirs. I want to shake my twelve-year-old self. I want to hold my hand next to my mother's, which is holding a spatula, to see how alike they are, now that I've caught up to her. In the family room, I turn a page; in the kitchen, my mother slides batter into the oven; on the lawn, the sprinkler beats out its summer cadence: *lost, lost, lost-lost-lost*. The flash at the window is a hummingbird, come to rest a moment at the feeder. I didn't listen when my mother told me to watch its ruby throat.

How to Comfort a Lost Star

Gather her into your arms to introduce her to the dog. Otherwise, the dog will lick her face and the star is still a bit wobbly. Her hands are dirty and she rubs her eyes with her knuckles so her face gets dirty, too. Praise her for letting the dog sniff her fingers. Try not to think about what comes next. She is familiar with darkness, so help her hear light breaking in the songs of the sparrow and thrush, in the wind rushing through the pines. The star has never dipped her foot in the stream or rubbed a daffodil against her cheek. Those two things take the whole morning, yet she is with you for only a moment. Show her the silkiest spot on the dog's head, just in front of the ear. Give her a sugar cube to pop in her mouth. Later, while the dog sleeps by the fireplace and the star sits drawing house after house with crayons, you can start whatever you meant to do this morning. And when the star looks up, pointedly, tell her—even if you have no idea how—you will help her find her way in the dark.

Sky Spirit

The sky spirit swoops, dips, then flies straight ahead so fast she's already gone when anyone turns to look. The air separates in waves, a mirage over a hot highway, when she passes through it. In flight, she's nothing like a paper doll dipped in glue. What are her duties exactly? She does not light the stars. She does not guide the airplanes, though she likes to hold up her thumb to cover their triangles of lights. She braids rain and sleet into a beaded curtain and pulls that curtain back to reveal the moon. She gathers the owls' calls, those almost-human sounds, which turn to strips of paper in her hands. If she could, she would write our fortunes on them, then shower them over us like confetti. But any kind of intervention, even quiet words, is not allowed. So she calls in fireflies to perch on her wiry curls while bats dart and weave through the shadows behind her. It is easy work, and she's grateful to be busy, because otherwise, like a parent, she'd have to watch us sleep as trees burn and lies catch fire.

A Rough Translation of Motherhood

Each morning, in the light, the unkempt field outside my window must become itself again. It is helpless. It does not think of me, so close by, watching the sunrise. The field never dreams of any kind of sky—not clear blue and cloudless, not electric with stars, not brimming with the near-deafening trill of spring peepers. That's all familiar as rain. When today, morning after the equinox, mist obscures the white farmhouse and the plowed field beyond, and beyond that, the elementary school and the highway, and obscures, above everything, the crows gliding and raucously calling, the field can rest its eyes for a bit. And feel nothing bearing down.

Cloud Report, 11/8/22

It's noon, and clouds press on the oaks lining my field. Not all of the rust-colored leaves have fallen. My entire sky is white with brushstrokes of ash and it's terrifying, like temporary blindness, like angels pulling a sheet over your eyes. Afterwards, it's a relief to see anything, even a piece of black construction paper with punched-out stars.

On I-96

When a dump truck passes us, we are not prepared for a
horse's stiff leg sticking out, rising and falling like a lever
pressed by an invisible hand. As she reads the truck's logo—
Noah's Pet Crematory—my daughter stumbles on the last
word. The large truck has tall sides and a deep bed. Even
when we look away, we can't forget the whole horse: it must
be resting on many other piled-up bodies. The white leg shifts
in and out of view. The truck is white. Even the air around
the leg is white. Above us, the sky holds its breath.

Bearing It

Today, in the sun, my field holds seven different kinds of beige.
To breathe and watch: we have to bear it. The clouds swell—
gray and white and more gray. Who'd pick a fight with the
trees? With the sky? So many have fled their windows and
can no longer say, *That barn is red. The farmhouse beside it
is white.* While smoke rises behind them.

Loons at Dawn, Gun Lake

Would you call it singing, that deep, eerie wail the loons make, haunting the lake and the mist that keeps sunrise from staining the water? After the loons speak—low and lingering like an impossible question—their voices echo inside me. The hair on my arms stands up. Would you call it mourning—despite this dawn bringing its smoke and ashes, its roses and mint—here beside the lake's still eye, wide open?

Inside Out

The girl turns the house inside out. Does it matter what she's looking for? She turns herself inside out. She turns the lake and the sky and the clouds inside out. Inside out, they are not much different. But the girl is tireless. She has only one assistant, a loyal dog the color of flame, and so much ground to cover. Behind her eyes, two swans drift among the lily pads, dripping with rain. Two more join them, then two more. She blinks away their slick feathers and black bills full of seaweed, then turns toward the constellations and the moon, which grows thinner every day. What difference will it make if she turns those things inside out? Dark is dark. And she is caught in its throat.

During the Pandemic

The factory of tears could not meet demand. After lentils and rice, butter and flour, people hoarded tears: small ones that glistened like sunlight on water, extra-large ones bright as moonstones, even frozen ones that turned cloudy the moment they thawed. People hid tears in their pantries behind the oatmeal and beans, under mattresses, and in glass jars buried in their backyards, which glowed up through the earth unless the holes were very deep. We told ourselves we were preparing for winter. The distance between us grew. Sorrow was as inescapable as sky, but we could bear the smaller ones: summer had turned to fall; owls and doves called each other at twilight and again at dawn. Leaves and feathers swirled through our yards as the November nights grew strangely warm and tricked us into opening our windows. We turned out our lights. We turned off our phones. The wind carried in the low hum of the thresher in the far field, harvesting corn, and the voices of our neighbors, arguing fiercely. All night, we held hands, one calamity away from running clean out of tears.

Constellations

Every morning I get up and walk in the dark, constellations rippling above me. I'm living in the poem of one more day, where I meet Linda for breakfast at Reeds Lake, where yellow oak leaves skid across the water. We sit on the patio. The babies at the next table blow raspberries and giggle in their mothers' arms. My friend talks and talks; we haven't seen each other in years. We don't know that a few hours earlier, a man stood on a nearby dock and shot himself. Or that sometime after we leave, a white dog with blue eyes will pull its owner to the water's edge.

Cloud Report, 5/28/23

Cruel, clear blue today, strewn with filmy lace. The oaks and maples have erupted—dark and soft, light and crisp—so much green signaling the breeze. Remember the night you called and said you might hurt yourself? It was the middle of winter. Almost invisible, these stretched-apart clouds remind me of your voice. Right now, the sun throbs somewhere beyond my view. A crow snags the afternoon in its beak and flies straight for it.

Picture of a Young Elk

It weighs nothing, this picture of a young elk tangled in a barbed wire fence in Montana. All four legs caught up at the ankle, eyes so glazed with shock it looks dead, and I almost don't play the video you sent. To spare myself. Though now my pleasure weighs something, as I listen to you tell and retell how you found a rancher with wire cutters and gloves in his truck and, nearly in one fluid motion, cut the fence and spun the elk toward the open field, across which, after it staggered and shook itself, it ran until it disappeared.

Aubade with Selfies

I'm waiting for the swirling snow to stop and finally reveal the horizon. Right this minute, I'm caught in a cloud: I can't see the field beyond the trees and if I could, it would also be white. My niece has just landed in Paris, and sits in a silver chair in front of a gilt-framed mirror, sipping coffee. Her updates find me almost instantly, here in the midst of the snow. Now I can't even see the trees.

Sleep Study

No window. Iron bedstead painted white, thin green cotton blanket turned down. No bowl of yellow apples or pears anywhere in sight. No mirror. In the hallway, on monitors, two strangers watched me sleep. They talked all night long, a low constant murmur that spilled through the crack around the doorway, outlined in light. They'd come in if I sat up and called them. They unplugged me from the machine and wrapped the wires around my wrist, so I could shuffle to the bathroom and back. The room was too hot. The lamps were too dim. In this fake bedroom, I lay awake while a herd of med students trampled across the ceiling. It rained, and in the rain headlights blurred into planets and stars. I heard another woman arrive; the strangers put her in a second room exactly like mine. Then the strangers watched us both, their voices rising and falling like a current, carrying us through the night.

The Sleep Thief

For years, when her children were small, she stole a little sleep from them each night. Just a few minutes' worth; what was the harm? She labeled the glass vials by name and date and time, and locked them in a fireproof safe. The sleep was colorless, though the longer she stored it, the more the vials glowed, an icy, rosy glow like winter mornings when dawn rose up from the frozen ground. She wanted run-of-the-mill, average sleep, so she skipped nights when they had fevers, birthdays, and Christmas. And nights they spotted shooting stars. If, at breakfast, a child reported falling off a cliff or being chased by lions, she poured that night's sleep down the drain; she couldn't risk nightmares infecting her collection. She had always intended, one day, to return the sleep to its rightful owners. But so many nights now, instead of lingering in the doorway to watch her children, she found herself in the basement, gazing at the rows of softly glowing vials, unable to tear herself away.

Magnificent Error

One summer night, the crescent moon fell in love with a black bowler hat and swore thereafter to follow it everywhere. But the hat did not succumb to the moon's charms. After a stroll through Luxembourg Gardens and then along the Boulevard St. Michel, caressed by the breeze of passing cars, the hat felt exposed. *I've been looked at all night long!* it cried. *Darling*, replied the moon, who had long ago grown used to the pressure of eyes, *at least come see the fifth-floor apartment I've rented for us.* The moon had wallpapered the apartment with sheet music. It had transformed a bowl of green apples into stone. It had paid its taxes and carried an umbrella in case of rain. In this way, it had successfully courted a porcelain rooster and the box of sugared violets displayed in the baker's window. In fact, the moon could still feel those objects clamoring for its attention. But then, the moon asked itself, why should it have to choose? The hat, the modest little hat with the canary feather stuck in its tattered lining, irritating the forehead of the portly man who motored it everywhere, that hat was something else entirely.

Circus Love Story

In private, far from the tightrope and open-mouthed crowds, he sprouted a water lily from his forehead. A little door opened and out it popped, all at once. Because tattoos on their biceps and collarbones could not contain their love. His beloved stepped into the kitchenette wearing a spangly red leotard. She said *oh* in the voice of someone who had dropped a key ring down a sewer grate. Practical questions—how long would it bloom? would it consume him? could he add it to the act?—never crossed his mind. Everything had happened a little too quickly. He would have preferred to flourish a top hat and present this prize to her: *for a limited time only*. Or: *the smallest show on earth*. For now, they could stop rowing the boat of their love across an ocean of eyes. The crow that haunted their days stopped tapping at the window and simply cocked its head. The water lily opened its sharp petals until the kitchenette glowed, muted gold, like twilight.

Little Gold Door

I open the little gold door of my mailbox, and ants and earwigs stream out, escaping the flames and screams that echo upward from deep underground. I slam it shut, but puffs of sulfurous smoke leak out and linger around it. One too many primary flyers for the Republicans, I figure. Still, I like Stan who delivers my mail, so I put up a second box and move the portal to hell to a fencepost in my backyard overlooking the field. Even the murder hornets avoid it. I can't bring myself to peek in again, although I'd like to know exactly who's arrived down there and who else might be coming. For the time being, the mailbox simply glowers, red-hot, silhouetted against the field of wheat.

Lone Ham

I'm skimming an essay on loneliness when the caption under a woodcut illustration stops me: *Lone Ham*. Maybe this essay goes beyond *suffering is caused by desire, it's the human condition, life is change and we resist*, etc. That Lone Ham—is it on a platter at Christmas or Easter, honey-glazed and vibrating with the loneliness of those who've gathered around it, who've somehow agreed not to mention politics or gender? That leaves mudslides and hurricanes. Or is it a pandemic ham, useless, riding out the holiday in the depths of a home freezer? The essay's in a newsletter that keeps on arriving, though I've unsubscribed multiple times, which leaves me to confront this existential ham on my screen. Well. How to go on? Like always, I guess, by considering the future an hour at a time and not all at once. For instance, I imagine my dog discovers the Lone Ham unattended—we've all left the table to admire the slant of light on the goldfish bowl— and feasts on it in wild delight.

I Didn't Want to Love the Dog

I was tired. Even tired, I loved the baby and her way of kissing the air beside my ear. Meanwhile, trees turned red and yellow on a regular basis. We shopped for bread and beans and glitter and paint. The baby grew into a girl who begged for a dog and cried herself to sleep. Once, she splashed in a lake the size of an ocean and searched for smooth black stones where water lapped the sand. No dog frolicked on shore. I spent my time on cooked carrots and crumpled band-aids, gum stuck in the backpack zipper. I craved sleep. I did not crave another volatile creature, a messy one who'd chew my things and lie next to me by the fire. The girl made lists of names. I was tired of arguing. Next time at the lake, the girl had just visited college and wanted to swim past the buoys. The red flags flew. Her dog dug a hole in the sand, stuck his nose in, and sneezed. I tried to explain the undertow, caution and restraint, but like so many times, my words blew away in the wind. The girl stroked the dog's silky ears and rubbed their noses together. Finally I said, *Your dog could never make it that far.*

Night Sky with Calculus Worksheet

The stars, numberless and mute, can't help you. That glimmer under a closed door might lead to a green banker's lamp or a pen scribbling, then swiftly crossing out. Doubt curls in your lap, kneading its paws and purring. Sleep is an elegant, lonely theory. The attic beams creak a little in the wind; the clock ticks *late, late, late*. Is an axe the inverse of greed? No, axe must equal greed which equals your ancient pine bed, shimmering upstairs like a mirage. In this particular case, bats flock like a physical whisper inside the eaves again. Tonight, one has blundered into the ductwork, and scrabbles now, softly, behind the furnace grate, tapping and tapping.

Cloud Report, 3/13/23

Now, almost evening, sparrows perch in low branches near the feeder, then swoop and land to peck for seeds. An angel, wings the color of old snow, slips in my back door and drifts to your room, examines a stray sock and peeks in your black sketchbook. The sky remains impassive, a calm, darkening mass. She lingers by the window to watch four deer gather in the field; soon they disappear in the sumac and pines. Daylight fails and we fall through it. When I switch on a lamp, the angel startles at the sudden bright pool.

Elegy for My Loneliness

Lately my loneliness has not had much to do. Every morning, laundry done, it looks out over the plowed field. White farmhouse, red barn. Not a person in sight. The frost on the black shingles glints and melts as the sun hits it. When my loneliness tries to write a letter, its sore wrist twinges. My loneliness is used to feeling like it's waving up from the bottom of a deep well. There's no help. A plane crosses the sky; against the windowpane, a fly buzzes.

Pandemic Ode

Oh gray horizon, gather me up. I am tired of learning to walk nicely on a leash. Soon the day will snatch me in its jaws—I never know exactly when. Its teeth are white and sharp as stars. I'd be your pet in exchange for the kind of sleep that doesn't strand me on my knees in a warehouse full of wedding dresses, searching for sequins and needles and lace. I'm happy to drink from puddles on the street. Happy to fetch sticks, or not, and drop them at your feet. Oh cloudless sky, gather me up and let me stay awhile, say you'll keep me safe. Safe from that breeze across my sweaty neck. Safe from that other self, snapping and growling inside her cage of bones.

At the Far Edge

Once I spread a plaid blanket in a field of wild mint, far from the road, where an insect hum rose and filled us, where a crow answered a crow. We were young enough that a parent expected us somewhere later on. The afternoon barely rippled when the crows called through it. We tried looking at the sky, and then you traced a fingertip along my palm. Whatever obligations we had rested on us like wings. I almost don't want to disturb her, that girl who smells of sunlight and pine, that version of myself who doesn't know what's about to happen. Look, she's brushing a wasp away from her collarbone. Now she's pulling a leafy twig out of her hair.

Under a Cloudless Sky

At the track meet, just yards from the finish, our slim girl in her orange jersey leaves the race to lie down in the grass, sobbing. The announcer does not note this despair in our midst. We wait thirty seconds, then thirty seconds more. The gun fires to start the next heat. When a coach finally reaches our girl, he kneels and puts a hand on her shoulder. Even from a distance, we see him help her breathe, by raising his palms and filling his own lungs, then letting his hands drift down.

Nightly

While I wait to fall asleep and escape myself, I think of my feet, then my ankles and calves. Each part grows briefly aware at being recognized, like being called on in school. If I think about my feet—cold, with a blistered bunion—I don't think of the future coiling around me. My mind is so easily led. If I think of a field of wheat in September, tawny and rippling, can I set it aflame? Will the fire kneel after it consumes every stalk? Can I conjure an expanse of water so large there's no shore in sight, waves swelling gently until dawn? Water understands restlessness. If I keep my eyes closed, I can feel those waves rising in each breath.

Long Walk in the Dark, August

This morning begins before dawn; I brush my teeth, the dog stretches and trots to the door. The birds are asleep, the lake is asleep, the insects that flood the air with their high-pitched tremble are awake. We've walked this route all summer— up past the patch of mint, down where road dead-ends in swamp. Here's where a man loaned me an umbrella during the pandemic. Here's the place where the couple, watering their geraniums, let my dog drink from their hose. And here's where I swear I saw my father, reincarnated, in a navy suit and tie, driving his red convertible down Beatrice Street. This morning, even with a flashlight, I can hardly see my way. I'm walking east, toward sky that's a little lighter than when I began.

Cloud Report, 1/18/23

Now the angels are in my kitchen, whipping cream in big silver bowls. I am tired of being afraid. When they look at the sky, an airplane slowly disappears into sweet white chiffon, bare wet trees stark against it. I didn't invite them, but like clouds, a few arrived anyway. They gaze over my shoulder toward the horizon when I ask, *What happens now?* They offer me a soft chair with the best view and a cup of hot chocolate, but the clouds form a wall as far as I can see. So the angels curl on the couch, then tuck their robes around their knees. Clearly, they have time.

Exam

When I drop quarters in the meter near Bronson Park, I always buy more time than I need. My optometrist says near-sighted people focus on what's within reach. If I remove my glasses, clouds form faceless smears; the horizon becomes a concept like kindness or faith. My optometrist is near-sighted, too, and doesn't mind when, in the darkened room, I can't choose between the lenses he flips through—one, or two? Better, or worse? His machine presses my head into the chair. He hands me a small laminated card, illuminates it, and asks me to read words the size of a grain of rice on the church steps, the freckle at the corner of my husband's mouth, my infant daughter's eyelash. As he takes the card back, he says I did well, only I've mistaken *tersely* for *tenderly*, and *alien* for *alive*.

Acknowledgments

Again, I'm grateful to Kevin Morgan Watson and Tom Lombardo of Press 53 for giving this book a wonderful home. Thank you both for your faith in my work, and, Tom, thank you for your attention to my poems. So many writers and friends helped make these poems possible. I'm indebted to Nin Andrews, who read many versions of this book and always answered my questions and reassured me. To my writing group—Robin Church, Melanie Dunbar, Elizabeth Kerlikowske, Jill Doster Marcusse, Amy Newday, and Julie Stotz-Ghosh—thank you for your positive energy, good ideas, and optimism. It's nice to have your company, especially when I am alone at my desk. Jeff Friedman valiantly brainstormed titles, for both the book and many poems. Gail Martin faithfully answered my out-of-the-blue emails, helped with titles, and encouraged me. Margaret DeRitter saved me from so many mistakes with top-notch proofreading. My brother, Jeff, supplied me with Blackwing pencils and provided tech support. And to Rhys, Charlie, and Lucy, all my love—these poems wouldn't exist without you.

Kathleen McGookey has published four books and four chapbooks of prose poems, most recently *Instructions for My Imposter* (Press 53) and *Cloud Reports* (Celery City Chapbooks). She is also the translator of *We'll See*, by French prose poet Georges Godeau. Her work has appeared in many journals, including *Copper Nickel, December, Epoch, Field, The Journal of Compressed Creative Arts, On the Seawall, Poetry East, Prairie Schooner, Ploughshares, The Southern Review*, and *Tupelo Quarterly*, as well as in the anthologies *Best Microfiction, Best Small Fictions,* and *New Micro: Exceptionally Small Fiction*. Her work has been nominated for both a Pushcart Prize and the Best of the Net, and has been featured on American Life in Poetry, Poetry Daily, SWWIM Every Day, and Verse Daily. She lives in Middleville, Michigan, with her family. Depending on the season, she waterskis, downhill skis, walks, and bakes pies.

www.ingramcontent.com/pod-product-compliance
Lightning Source LLC
Chambersburg PA
CBHW021511090426

42739CB00007B/567